GRAPHIC FRAMES

SHAMBHALA AGILE RABBIT EDITIONS

BOSTON

1999

# GRAPHIC FRAMES

Shambhala Publications, Inc.
Horticultural Hall
300 Massachusetts Avenue
Bostzon, Massachusetts 02115
*http://www.shambhala.com*

987654321
Printed in Singapore
∞ This edition is printed on acid-free paper that meets the American National Standards
Institute z39.48 Standard.
Distributed in the United States by Random House, Inc., and in Canada by Random House
of Canada Ltd

See page 8 for Cataloging-in-Publication data

Other books with CD-ROM by Shambhala Agile Rabbit Editions:

ISBN 1-57062-477-1    Batik Patterns
ISBN 1-57062-480-1    Chinese Patterns
ISBN 1-57062-483-6    Decorated Initials
ISBN 1-57062-478-x    Floral Patterns
ISBN 1-57062-479-8    Images of The Human Body
ISBN 1-57062-482-8    Sports Pictures
ISBN 1-57062-481-x    Transport Pictures

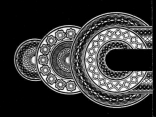

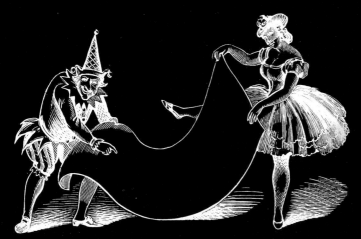

Library of Congress Cataloging-in-Publication Data

Graphic Frames / [compiled by Pepin van Roojen].
        p.   cm.
    ISBN 1-57062-484-4 (alk. paper)
        1. Cartouches, Ornamental (Decorative arts)        I. Roojen, Pepin
van.
NK1585.G73 1999
745.4–dc21                                                      99-19175
                                               CIP

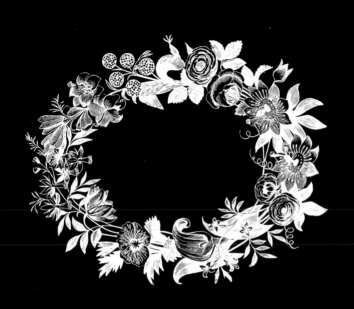

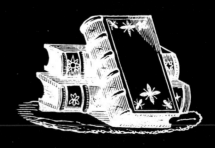

This book contains high-quality images for use as a graphic resource or inspiration. All the images are stored on the accompanying CD-ROM in professional quality, high-resolution format and can be used on either Windows or Mac platforms. The images can be used free of charge.

The documents can be imported directly from the CD-ROM into a wide range of layout, image-manipulation, illustration, and word-processing programs; no installation is required. Many programs allow you to manipulate the images. Please consult your software manual for further instructions.

The names of the files on the CD-ROM correspond with the page numbers in this book. Where applicable, the position on the pages is indicated: T = top, B = bottom, C = center, L = left, and R = right.

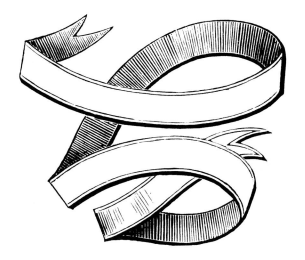

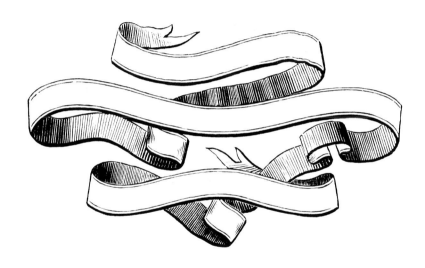

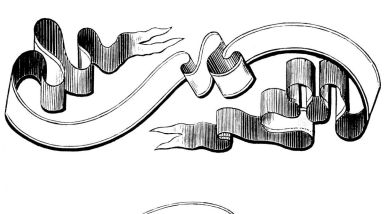

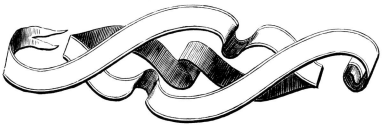

31

69

113

133

141

144

147

166

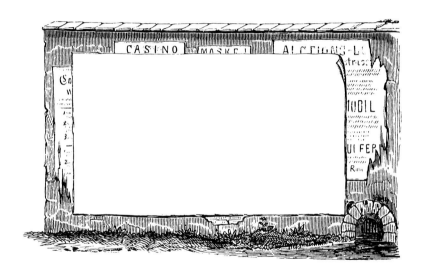

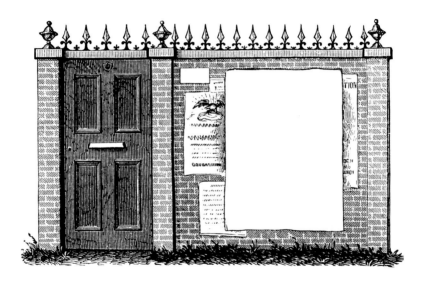

205

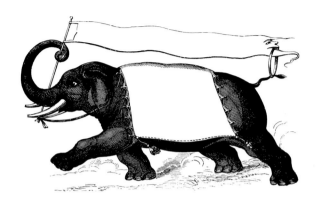

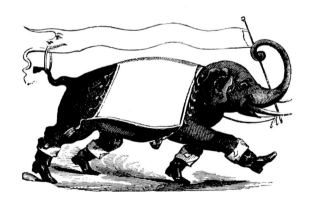

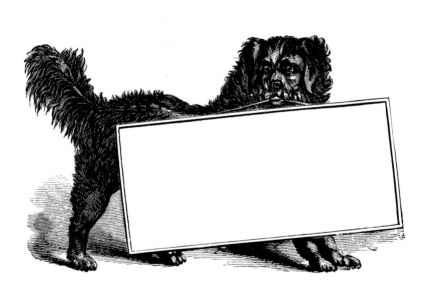

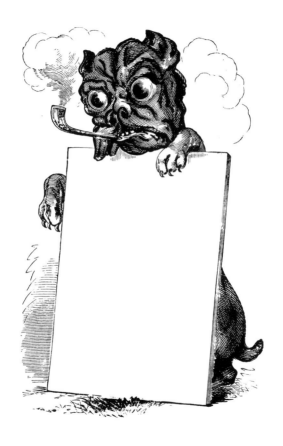

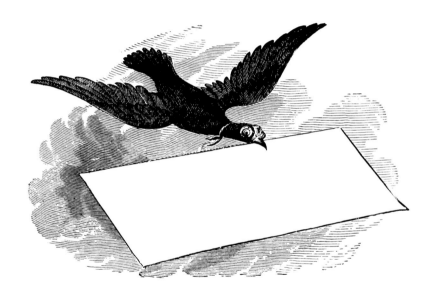

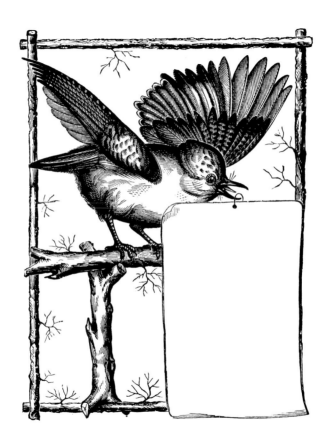

211

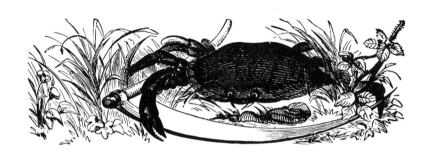

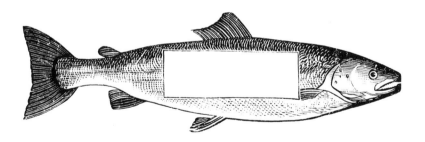

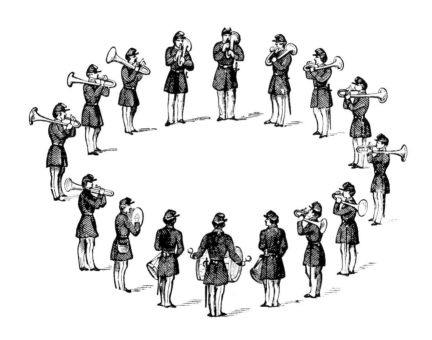

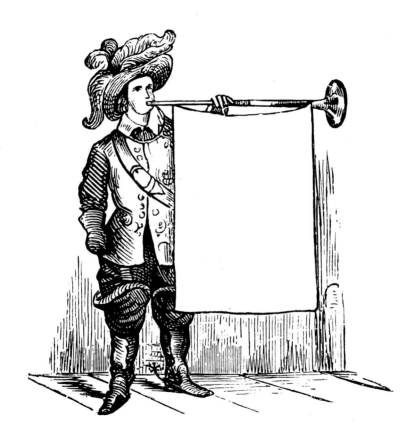

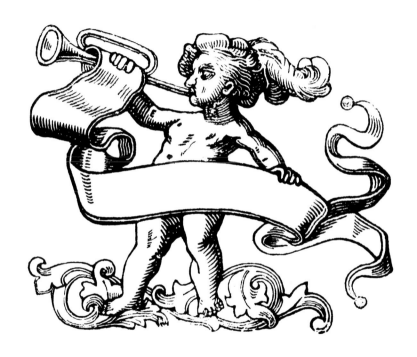

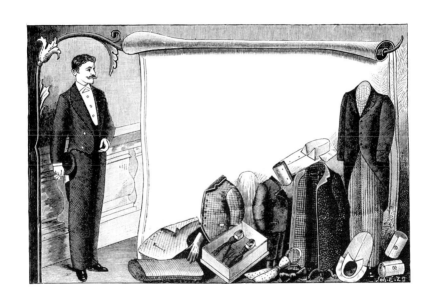

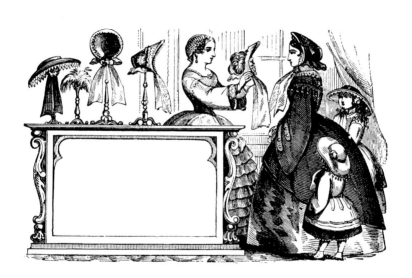

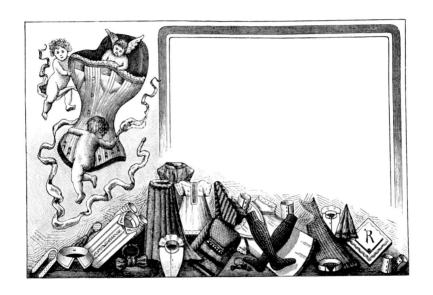

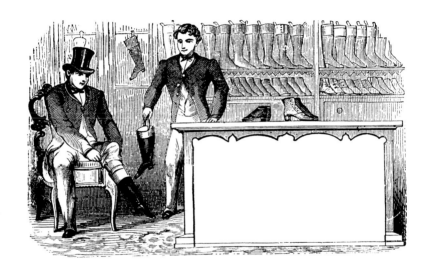

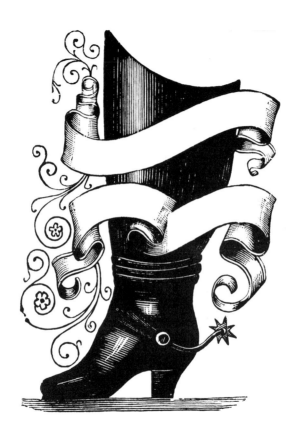

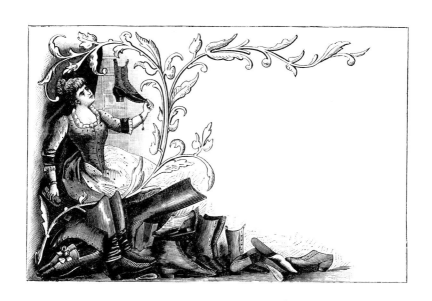

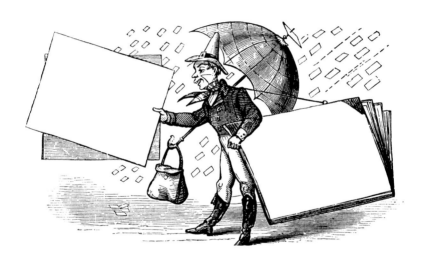

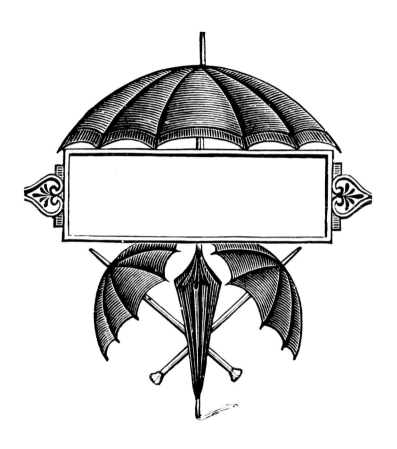

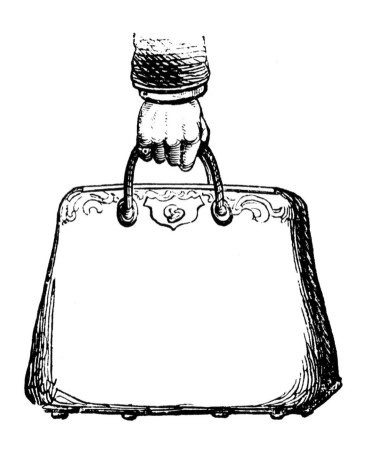

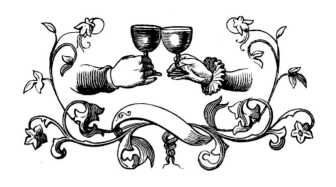

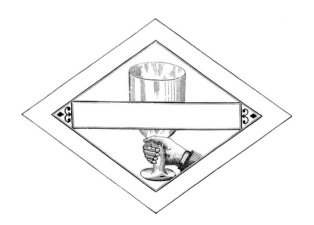

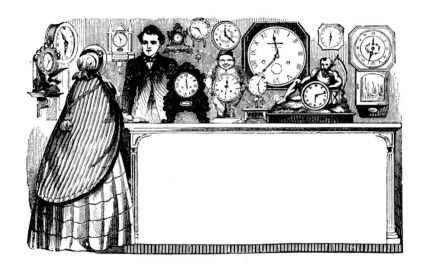

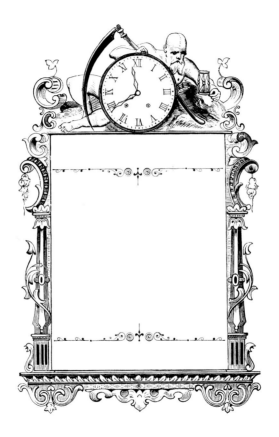

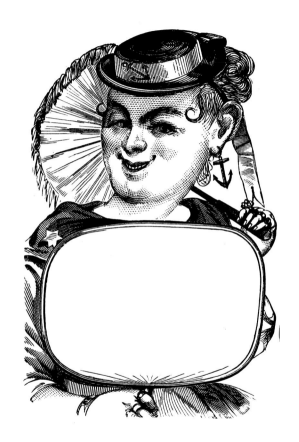

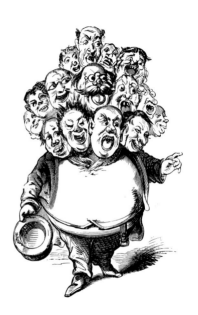

249

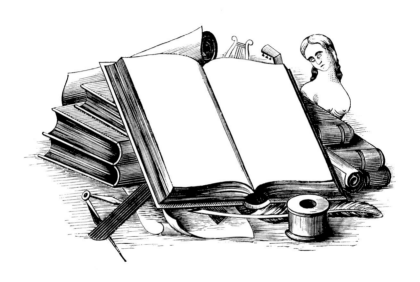

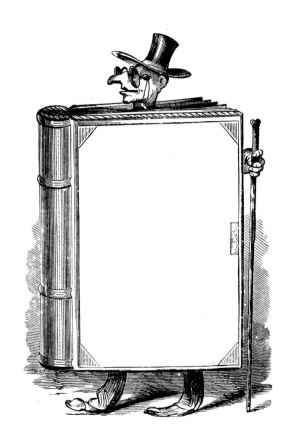

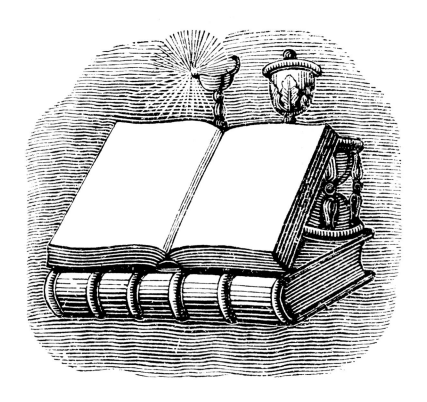

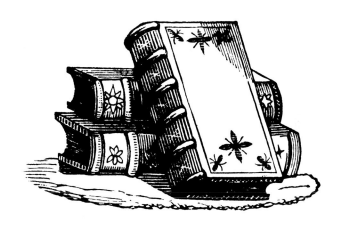

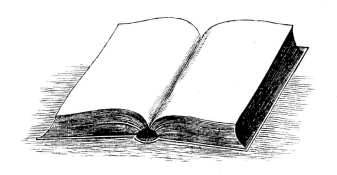

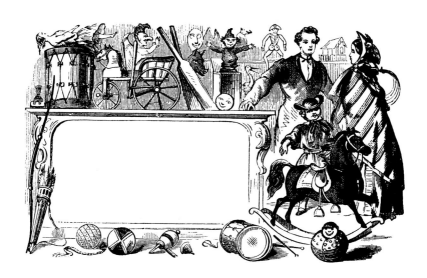

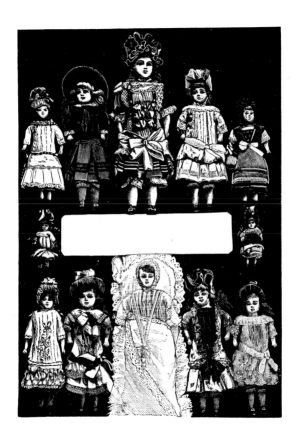

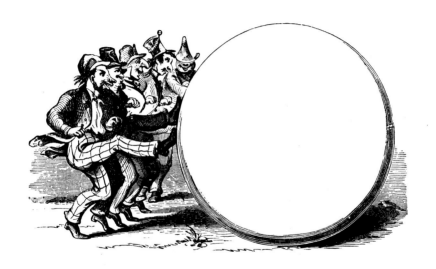

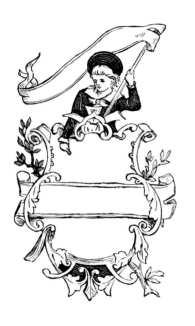

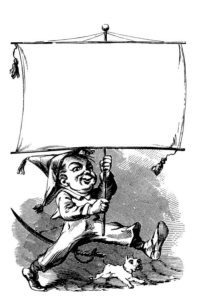

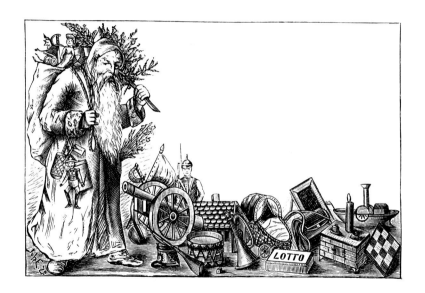

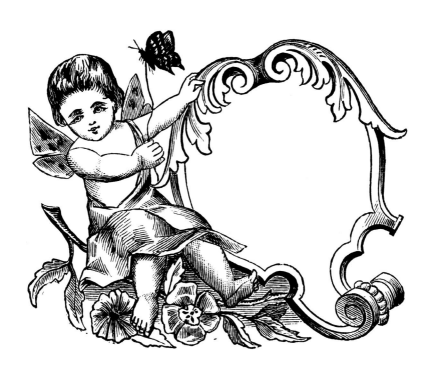

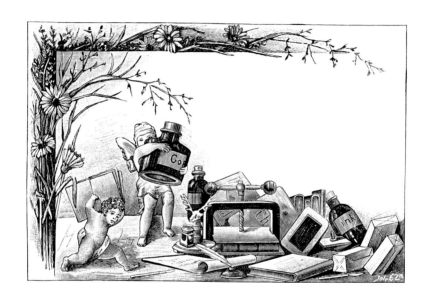

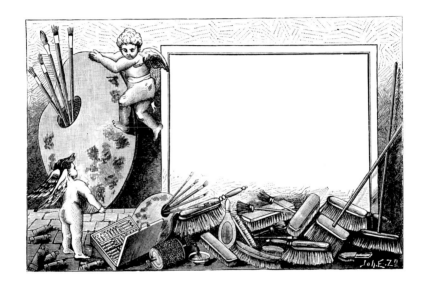

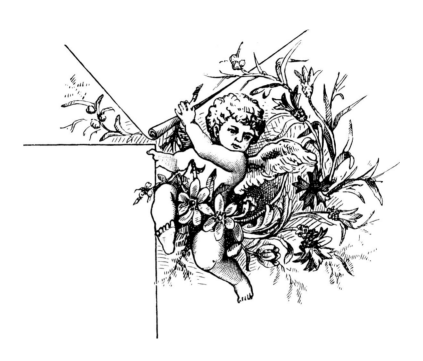

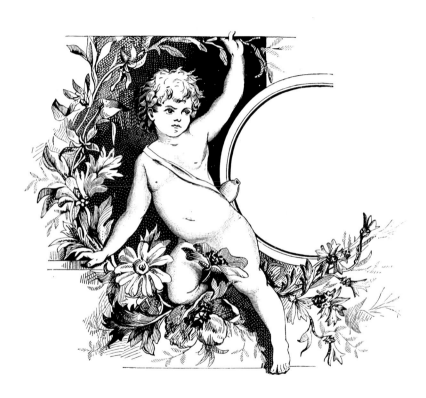

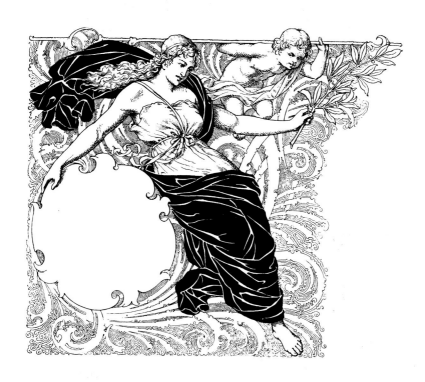

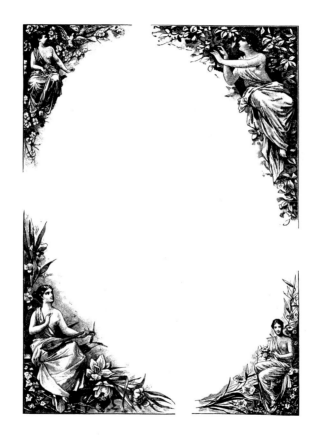

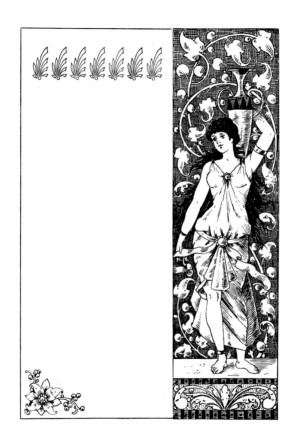

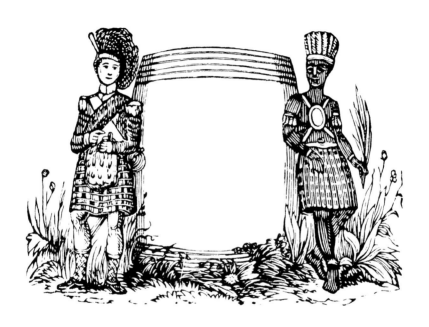

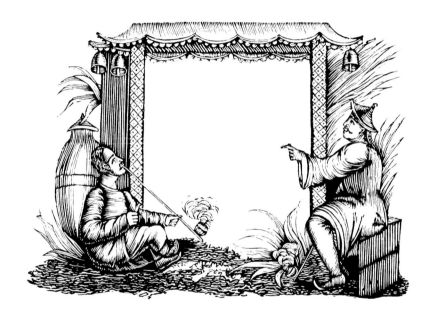

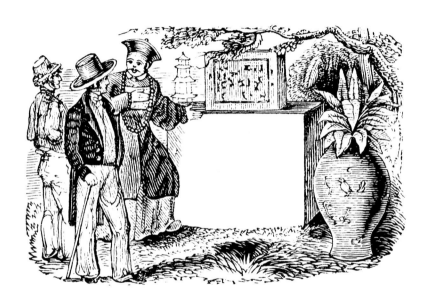

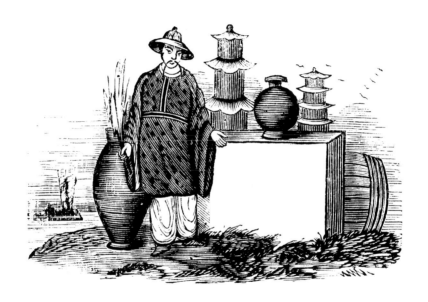

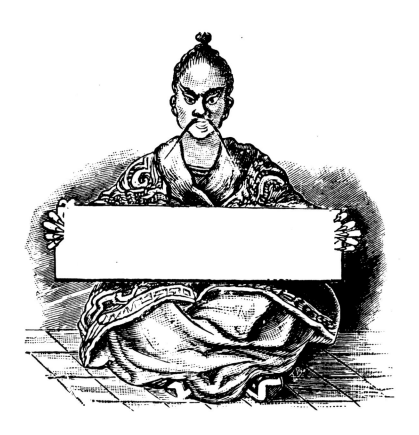

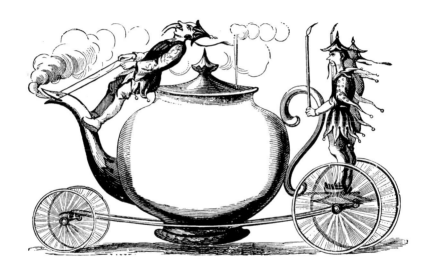

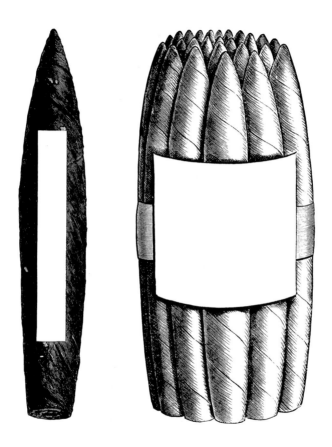

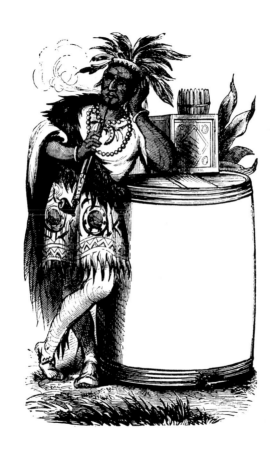

307

318

322

327

332

334

339

341

345